Henri Matisse

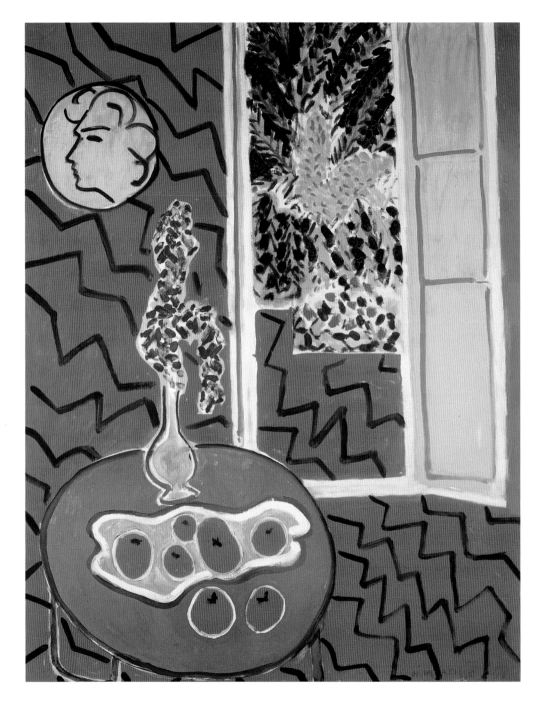

Henri Matisse

Juliette Rizzi

Tate Introductions
Tate Publishing

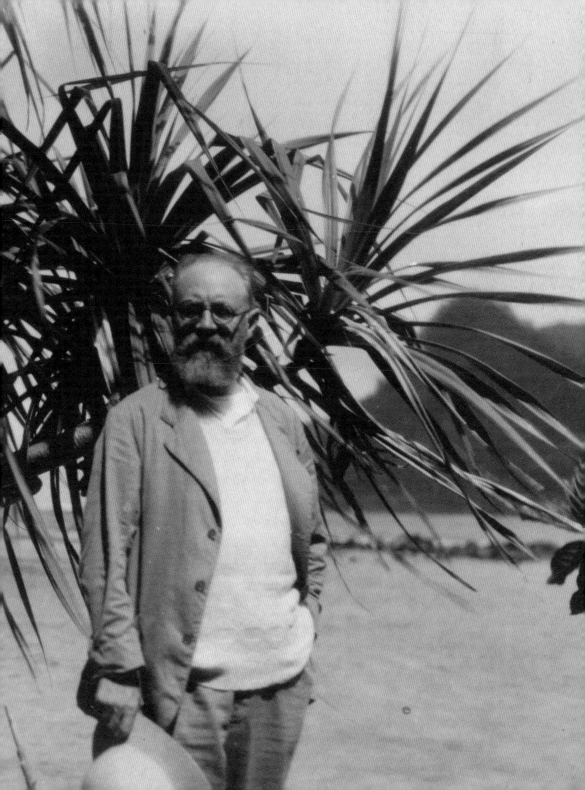

A box of colours

What I am after, above all, is expression.[1]

Henri-Émile-Benoît Matisse was born on 31 December 1869 in the textile town of Le Cateau-Cambrésis, in the Picardy region of France. His father, Émile Hippolyte Henri Matisse, came from a family of weavers, and his mother, Anna Héloïse Gérard, was the daughter of a tanner (fig.2). Henri was the eldest of three brothers, one of whom died at the age of two. Soon after Henri was born, the family moved to Bohain-en-Vermandois, a small town twelve miles from his birthplace. There the family opened a store from which Matisse's father mainly sold grain and seeds, but from which his mother also sold house paint and mixing pigments, and advised clients on colours and decorative styles. Throughout childhood, Matisse suffered frequent bouts of intestinal trouble which left him weak and incapacitated for weeks on end, and these, it is believed, may have been brought on by his anxiety over the prospect of having to take over the family business. He later reflected, 'I was a child with my head in the clouds'.[2]

From 1882 to 1887, after attending the Collège de Saint-Quentin, Matisse studied classics at the Lycée Henri Martin in the same town, and in 1887 was sent to Paris to study law. He passed his law examinations in August 1888 and returned to Bohain, and in 1889 started to work as a clerk in a law office in Saint-Quentin. Then came a pivotal moment; when an acute attack of appendicitis forced him to convalesce at his parents' house for several months, his mother gave him a paintbox to relieve his boredom. Having spent his childhood on the great Flanders plain, in a society offering 'little imaginative outlet beyond its fairs, the occasional travelling circus and games of knights-on-horseback',[3] it was only now that his interest in painting began and grew. Matisse himself identified this as the period in which his dedication to art began.

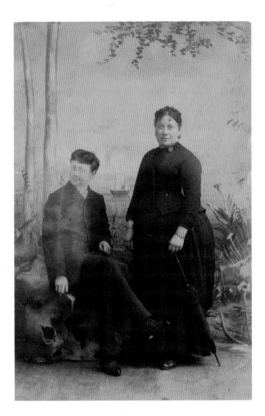

2. Matisse at the age of nineteen with his mother, Anna Héloïse Gérard Matisse, 1889
Archives H. Matisse

Before, I had no interest in anything. I felt a great indifference to everything they tried to make me do. From the moment I held the box of colours in my hand, I knew this was my life. Like an animal that plunges headlong towards what it loves, I dived in, to the understandable despair of my father … It was a tremendous attraction, a sort of Paradise Found in which I was completely free, alone, at peace.[4]

He began by buying an instructional handbook called *Complete Manual of Painting in Oils* by Frédéric Goupil, and in the summer of 1890 produced his first painting, *Still Life with Books* (fig.3), later renamed *My First Painting*. After his recovery, Matisse started to work for Maître Derieux, a lawyer in Saint-Quentin, but continued to pursue his new-found interest in painting and drawing. He enrolled in a free art school where, by attending classes early in the morning, he learned how to draw and paint.

By 1891 Matisse had become dissatisfied with his life and work at Saint-Quentin and decided to move to Paris. Despite disapproving of his ambitions to become a painter, Matisse's father supported him with 100 francs a month, and paid for his tuition fees at the Académie Julian, a private school, where he attended the classes of the highly respected William-Adolphe Bouguereau. Quickly, though, Matisse found Bouguereau's teaching too conservative:

> Don't rub out the charcoal with your fingers – that denotes a careless man; […] you'll have to understand perspective … but first you must learn how to hold a crayon …[5]

Torn between his respect for academic technique and his desire to break new ground, the young Matisse failed the entrance examination to the École des Beaux-Arts in February 1892. Discouraged, he left Bouguereau's classes, but the works of Goya and Chardin at the Musée des Beaux-Arts in Lille inspired him to continue pursuing his artistic ambitions. He enrolled at the École des Arts Décoratifs for a teaching diploma and began to attend a course in perspective and geometry, but it was an encounter with symbolist painter Gustave

3. Henri Matisse
Still Life with Books
1890
Oil paint on canvas
21.5 × 27
Musée Matisse, Nice

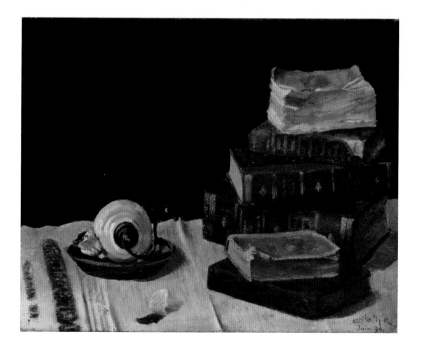

Moreau that provided Matisse with a direction and influence that was previously missing. He started to attend Moreau's classes unofficially in 1892, where he was taught to 'look inwards'[6] and 'to represent the concept of an object, irrespective of its actual visual appearance'.[7] Moreau also encouraged his pupils to visit the Louvre and imitate artists like Chardin, Watteau, Fragonard, Poussin and Jan Davidsz. de Heem (fig.4), as well as to practise sketching in the streets. Matisse chose Chardin as his favourite and he began to explore variation of tone as a means to bring out greater qualities of light amid softer hues.

In the summer of 1894 Matisse moved to 19 Quai St-Michel, the first studio he was to live in on his own and to which he would return for years to come. Eventually, Matisse was accepted at the Beaux-Arts in 1895 and continued to attend Moreau's classes (fig.5), where he befriended the painter Georges Rouault. His first visit to Brittany, in the summer of 1895, gave rise to an interest in painting outdoors. In 1896, following the exhibition of five paintings at the Salon de la

4. Henri Matisse
Still Life after Jan Davidsz. de Heem's 'La Desserte'
1893
Oil paint on canvas
72 × 100
Musée Matisse, Nice

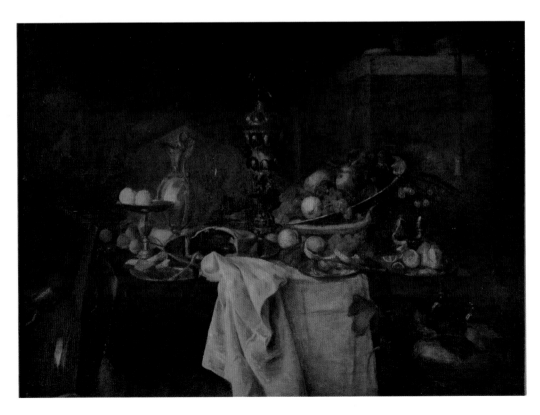

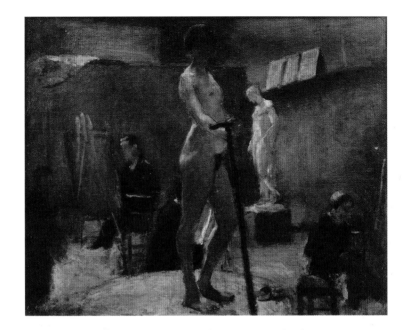

5. Henri Matisse
The Atelier of Gustave Moreau
1894–5
Oil paint on canvas
65 × 81
Private collection

Société Nationale des Beaux-Arts, and the purchase by the French State of two of his works, Matisse was elected to Associate Membership of the Société Nationale. In spite of this recognition from the conservative establishment, Matisse turned his attention more and more to modern art, using increasingly impressionistic techniques (fig.6).

Matisse was now beginning to grow in self-confidence. He sought the company of his fellow artists and developed his interest in impressionism. He often visited the Durand-Ruel gallery, which exhibited works by the impressionists, as well as the new Ambroise Vollard gallery, which showed works by Vincent van Gogh and Paul Cézanne. Camille Pissarro, the 'elderly father of impressionism',[8] took him to see the Gustave Caillebotte bequest of paintings at the Musée du Luxembourg in Paris. It was Pissarro who first encouraged Matisse to go to London to see paintings by J.M.W. Turner. The spring of 1897 saw the culmination of this impressionistic influence in Matisse's first 'modern' painting, *The Dinner Table* (fig.16).[9]

Matisse's personal life up to this point had been tumultuous. In 1893 he had begun a relationship with Caroline Joblaud, who gave birth to their daughter, Marguerite, a year later. In early 1897,

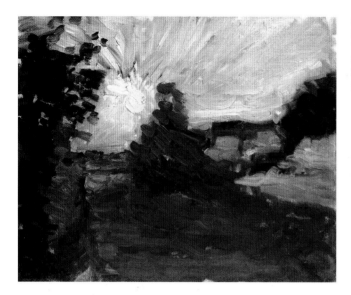

6. Henri Matisse
Sunset in Corsica
1898
Oil paint on canvas
32.8 × 40.6
Private collection

Matisse signed paternity papers such that Marguerite could legally be his daughter. By the summer the relationship with Joblaud had ended and he met Amélie Parayre, whom he married in January 1898. Marguerite would go on to live with her father and play an important role in his *oeuvre* until his death. Matisse and Parayre spent their honeymoon in London, where Matisse first became fascinated by Turner's paintings at the National Gallery. They then visited Marseille, Ajaccio and finally Toulouse, where Amélie gave birth to their first son, Jean Gérard, in early January 1899. 'Everything shone, all was colour, all was light',[10] Matisse recounted of his first experience in the sunnier south, and from this moment on his works began to reflect that same light, using vivid and arbitrary colours. His work of this period, the so-called 'proto-fauve', owed much to the influence of neo-impressionism and the work of Cézanne (fig.17).

Soon after the death of his former teacher Moreau in April 1898, Matisse left the Beaux-Arts, exhibiting for the last time at the Société Nationale in 1899. He was still not fully accepted as an avant-garde artist and exhibited only once at the Salon des Indépendants in 1901. Through his frequent visits to the Ambroise Vollard gallery, Matisse's admiration for Cézanne greatly increased, so much so that he bought Cézanne's *Three Bathers* (fig.7), which he kept until giving it to the Petit Palais in Paris in 1937:

I have owned this canvas for thirty-seven years and I know it fairly well, I hope, though not entirely; it has sustained me spiritually in the critical moments of my career as an artist; I have drawn from it my faith and my perseverance […][11]

Toward the end of 1899 Matisse began to experience a reversal of fortunes which reached its lowest point between 1902 and 1904, a period famously labelled by his biographer Alfred H. Barr, Jr. the 'dark years'.[12] His paintings were not receiving recognition and his father was unable to contribute regularly to his living costs. Uncharacteristically, Matisse started painting standard subjects for popular consumption. Although Amélie had opened a millinery shop in Rue de Chateaudun in Paris to support the family, they were eventually forced to move back to Bohain, where they were based until 1904 and where their second son, Pierre Louis Auguste, was born in June 1900. Matisse continued to spend some time in Paris, where he attended classes at the Académie Carrière, and it was there he established the group of painters that came to be known as the fauves ('wild beasts'). His works from this period reflect his interest in sculpture and the work of Cézanne (figs.18–20).

7. Paul Cézanne
Three Bathers
1879–82
Oil paint on canvas
52 × 55
Le Petit Palais, Paris

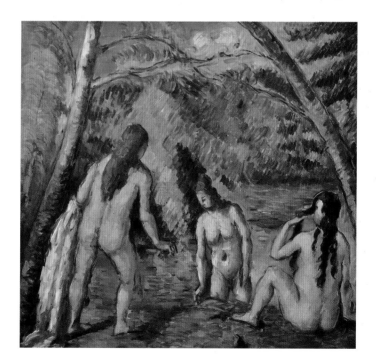

Matisse's first one-man show was in June 1904 at the Ambroise Vollard gallery; it was not a great success but he did sell some works. He spent the summer of 1904 in Saint-Tropez, in the home of the neo-impressionist Paul Signac, where he painted bold and colourful landscapes, reverting to an uncompromising, neo-impressionistic style (fig.21). There he developed his first imaginary composition, *Luxe, calme et volupté* (fig.22), and this later came to define Matisse's style. It was exhibited at the Salon des Indépendants in 1905 and, though controversial, would begin to establish him as a leader among his contemporaries.

Wild beasts

The critics already began to note the violent color and freedom of line and form which united these younger artists […][13]

As Matisse's financial situation began to improve, he and his family were able to return south and spend the summer of 1905 in Collioure, close to the Pyrénées. There, he was joined by his friend André Derain, with whom he had recently exhibited at the Salon des Indépendants. Both artists now produced their first purely fauvist paintings (figs.8, 23). On his return to Paris, Matisse started to paint *Woman with a Hat* (fig.24), one of his most famous fauvist works, described as '[…] a picture of his wife that violently transposed into portraiture the high-keyed colours he had unleashed in the Collioure landscapes'.[14] That October the works of Matisse, together with those of Vlaminck, Camoin, Derain, Manguin and Marquet, were exhibited in room VII of the Salon d'Automne alongside two academic sculptures. This led the critic Louis Vauxcelles to exclaim, 'Donatello chez les fauves',[15] and thus the term 'fauve' was coined.

Among the many criticisms made of the fauvists' work at the time was that of Marcel Nicolle:

[…] what is presented to us here […] has nothing whatever to do with painting: some formless confusion of colors; blue, red, yellow, green; some splotches of pigment crudely juxtaposed; the barbaric and naïve sport of a child who plays with the box of colours he just got as a Christmas present.[16]

8. André Derain
Henri Matisse
1905
Oil paint on canvas
46 × 34.9
Tate

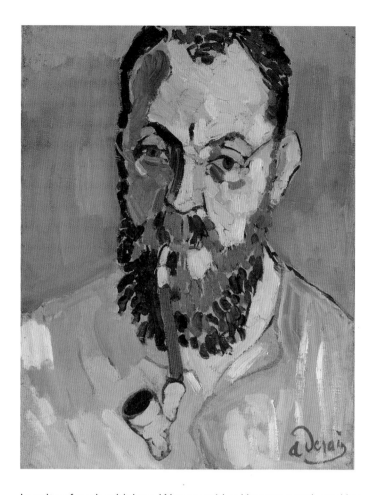

In spite of such criticism, *Woman with a Hat* was purchased by the renowned collectors the Stein family[17] and this, according to Alfred H. Barr, Jr., marked a turning point in the fortunes of Matisse the artist. The Stein family were to become important collectors of his work and introduced him to others, such as Etta Cone.

At the end of 1905 Matisse rented a studio in the Couvent des Oiseaux where he began painting *Le Bonheur de vivre* (fig.25), described as a departure from pure fauvism and offering 'instead an effect of indolent calm, using broad areas of colour bounded by arabesque contours [...], populated by images of sexuality'.[18] When this large work was exhibited at the Salon des Indépendants in 1906 it caused widespread outrage.

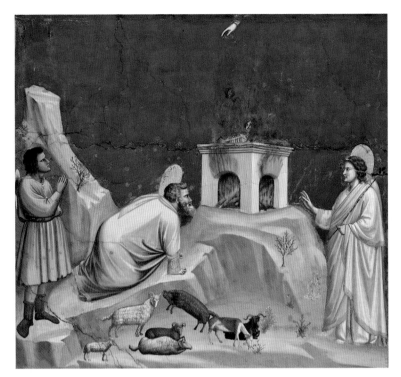

9. Giotto di Bondone
Joachim's Sacrifice
1303–5
Series of frescoes (before
restoration in 2002)
Scrovegni Chapel, Padua

Matisse then travelled to North Africa, visiting Algiers, Constantine, Batna and Biskra, and became fascinated by the colours and quality of light. Toward the end of the winter of 1906 he also started to analyse the distinctive practice of sculpture with regard to volume and mass (figs.27, 28), noticing African carvings in Parisian curiosity shops. The work *Blue Nude: Memory of Biskra* (fig.26) admirably reflects upon this analysis, as well as the influence of North Africa.

In the summer of 1907, Matisse visited Italy, where he was struck by works by Piero della Francesca and Giotto (fig.9), among others. By now Matisse was recognised as one of the most important living artists in France and one of the leaders of the fauvist mouvement. The works that Matisse produced in this period are reminiscent of Giotto and the primitives, and show the influence of Cézanne, but most importantly they reveal his developing interest in the decorative (fig.29).

The decorative

> What I dream of is an art of balance, of purity and serenity, devoid of troubling or depressing subject matter [...] [19]

Towards the end of 1907, Sarah Stein and Matisse's friend Hans Purrmann suggested to him that he organise classes to teach a small group of friends on a regular basis. The 'Académie Matisse' [20] opened in the Couvent des Oiseaux, which housed the large studio where he had lived and already painted *Le Bonheur de vivre*. The Académie initially 'functioned more like an extended family than an academic institution',[21] but would expand. Matisse taught sculpture, painting and drawing, especially from the living model.

Matisse continued his interest in simplified forms and flatness of colour, painting various figurative compositions. When the Couvent des Oiseaux was sold later that year, Matisse had to move to the Hôtel Biron, formerly Couvent du Sacré Coeur, and there completed *Harmony in Red* (fig.30), a work that revealed his renewed interest in still lifes, interiors and, most importantly, the decorative. *Harmony in Red* [22] had been commissioned by Sergei Ivanovich Shchukin, a Russian textile magnate, whom Matisse had met in 1906 and who had previously bought some of Matisse's smaller works. Shchukin was to become one of the most important supporters and collectors of Matisse's art, and also commissioned the two large decorations *Music* and *Dance II* (figs.10, 32),[23] subsequently remarking in 1909: 'I find your *Dance* panel so noble that I have made up my mind to brave bourgeois public opinion here and hang a subject with nudes on my staircase.'[24] Both works were shown at the Salon d'Automne in 1910, and continued to reflect the influence of Giotto, contrasting strikingly with the developments of cubism in the same period.

Matisse's 'Notes of a Painter' had been published in *La Grande Revue* in 1908. This text documented Matisse's own ideas on art and remains his most significant written work.

In late 1909, Matisse and his family moved to a house in Issy-les-Moulineaux, a suburb of Paris, which he promptly decorated with paintings, carpets, textiles and art objects. The same year Matisse signed a three-year contract with the Bernheim-Jeune gallery, providing him with regular income, and held his first retrospective

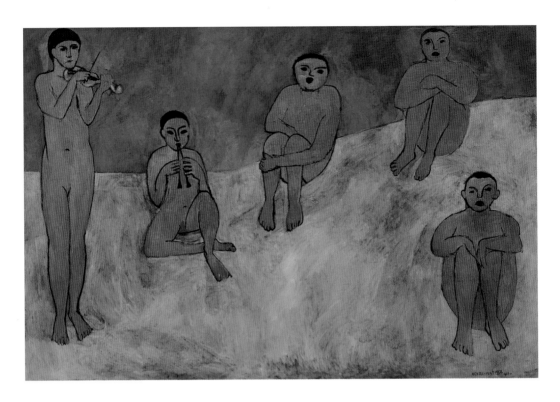

10. Henri Matisse
Music
1910
Oil paint on canvas
260 × 389
State Hermitage Museum,
St Petersburg

there in 1910. This received so much criticism that the poet and critic Apollinaire noted that the entire press treated Matisse with 'a rare violence'.[25] Nevertheless Matisse's reputation spread, with exhibitions held in Florence, London, New York and Berlin, among others. On a visit to Germany in the same year, Matisse took the opportunity to see an important exhibition of Islamic art in Munich, where he encountered the rugs, bronzes and miniatures which were to influence the famous Interiors he painted soon afterwards. His 'Symphonic Interiors' began in early 1911, reflecting both the influence of Persian miniatures and the rejection of Western perspective, shifting the emphasis to flat planes of colour and taking a step beyond the abrupt, dispersed brushstrokes of fauvism (figs.33–5).

In early 1912 Matisse resumed his travels abroad and over the next two years would make two trips to Morocco, which gave rise to his 'Moroccan period'. This included the production of the large work *The Moroccan Café* (fig.37), '[…] a luminous, trancelike suspension

11. Henri Matisse
*Interior with a
Goldfish Bowl*
Spring 1914
Oil paint on canvas
147 × 97
Musée national d'art
moderne, Centre
Pompidou, Paris

of space and time that conveys to perfection the "utter calm" the artist had found in Tangier'.[26]

As Alfred H. Barr, Jr. noted, Matisse, along with Picasso and Braque, were by now becoming recognised as 'the leaders of the Modern movement', albeit for very different reasons. Picasso and Matisse had met in 1906 at the Steins' house and fostered one of the most influential relationships in twentieth-century art; they would become equally rivals and foils.

A restless time

[…] Matisse had changed from an unknown young art student into one of the two key innovators to whom the art-world looked for leadership from New York to Moscow.[27]

After an exhibition of his Moroccan paintings at the Bernheim-Jeune gallery in April 1913, Matisse spent most of the year at Issy-les-Moulineaux, travelling seldom. One of the few works he produced

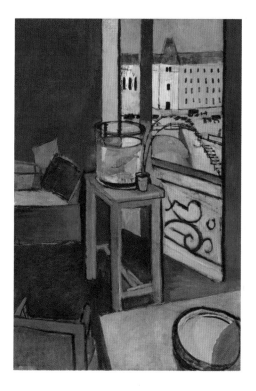

during this time was *Portrait of Madame Matisse* (fig.39), the last painting Shchukin bought. Between 1913 and 1914 Matisse, having eventually bought the house at Issy-les-Moulineaux, occasionally returned to his new studio in Paris, at 19 Quai Saint-Michel. In 1914 he produced *Mademoiselle Yvonne Landsberg* (fig.38), with its voluptuous curves expanding the figure outwards into the surroundings, but despite continuing to exhibit abroad, Matisse often found it impossible to concentrate on his work following the outbreak of the Great War.

The years following the trips to Morocco are considered to be the most 'Un-Matissean'.[28] He experimented with abstraction and geometry, lending a new stylistic aspect to his work that reflected the influence of cubism (fig.41). In the summer of 1915 he repainted *La Desserte* (fig.40) for the third time: the first copied the style of the masters, the second was more impressionistic, and the third interlaced sharp lines and bold colours in a distinctly cubist composition. He produced his most famous pieces of this period between 1916 and 1917, returning to some of his unfinished paintings and sculptures and reworking them (fig.42).

It is clear that concerns about the War continued to prey heavily on Matisse's mind; in a letter to his friend Hans Purrmann, dated 1 June 1916, he wrote:

what a gravity it will have given to the lives even of those who did not participate in it if they can share the feelings of the simple soldier who gives his life without knowing too well why but who has an inkling that the gift is necessary. [...] Painters, and I in particular, are not clever at translating their feelings into words – and besides a man not at the front feels rather good for nothing ...[29]

Matisse himself had attempted to enlist in August 1914, but had been rejected.

12. Henri Matisse
Violinist at the Window
Spring 1918
Oil paint on canvas
150 × 98
Musée national d'art
moderne, Centre
Pompidou, Paris

The light in the south

Nice, with its steady, unchanging light, gave him the pictorial
equivalent of laboratory conditions in which to reshape the future.[30]

Perhaps due to growing conflict with Amélie, Matisse started to
spend more time alone in Nice, where he rented a room in the Hôtel
Beau Rivage. Here he painted a number of Interiors which departed
from the previous decorative and experimental works, using a softer
palette of colours to diffuse light gently across subjects and objects
(figs.12, 43).

Among the many fellow artists whose company he enjoyed around
this time, the most significant was the impressionist Pierre-Auguste
Renoir, now in his advanced years, who Matisse visited in the spring
of 1919. Matisse would bring him paintings for critical judgement and
it may be that as a result of Renoir's influence we see a naturalistic
style becoming a part of Matisse's early work in Nice.

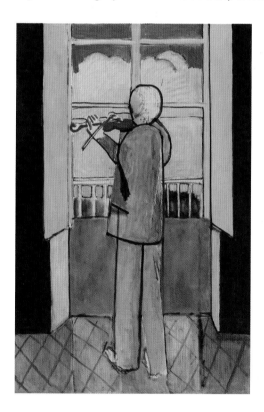

There followed a significant moment in Matisse's career: between 1919 and 1920 he was invited by the impresario of the Ballets Russes, Sergei Diaghilev, and composer Igor Stravinsky to design costumes and sets for the ballet *Le Chant du Rossignol* (*The Song of the Nightingale*), choreographed by Léonide Massine. Matisse viewed his own work '[...] like a painting, only with colours that move'[31] and instinctively used coloured paper cut-outs in a scale model of the Empire Theatre, Leicester Square in London.

Matisse's mother, who had been hugely important for him, died in January 1920, a week before the ballet opened.

In 1921, the next of Matisse's many moves was to an apartment in Place Charles Félix in Nice, where he stayed until 1928.[32] He transformed the new space with paintings, mirrors, fabric hangings and decorative screens. It is here that he started his series of Odalisques, accompanied by etchings and lithographs. These works stood between abstraction and realism, depicting seductive models in overtly opulent settings, creating an almost surreal atmosphere (figs.44, 45). It seems Matisse became quite settled in this new apartment, only making trips to Paris, Normandy, and a return to Italy. One of his visits to Paris was to attend the wedding of his daughter, Marguerite, to the scholar Georges Duthuit at the end of 1923.

Despite ongoing and widespread recognition between 1924 and 1931, including an exhibition at his son Pierre's newly opened gallery in New York, the general public was still not ready to embrace Matisse's fauve paintings, seeming to prefer his Nice Interiors instead. Matisse slowly reduced his work on easel paintings, but revived his interest in sculpture (fig.46).

Travel and travail

> I stayed there three months absorbed by my surroundings without a thought in my head in front of the novelty of everything I saw, dumbfounded, yet unconsciously storing up a great deal.[33]

By 1930, Matisse had re-indulged his passion for travelling by visiting Italy, Spain, Algeria, Morocco and various regions in France, but now he decided to go further afield. Initially he visited the Metropolitan Museum in New York, seeing works by Cézanne, Degas, Renoir and Courbet, as well as Rembrandt. He then continued on to California

13. Henri Matisse
The Dance
1932–3
Oil paint on canvas
Left: 339.7 × 441.3;
centre: 355.9 × 503.2;
right: 338.8 × 439.4
The Barnes Foundation,
Philadelphia

to embark for the Polynesian island of Tahiti, where he remained for three months, not painting but making drawings and sketches (fig.1). He was fascinated by the waters of the lagoon, in particular the pastel shades of coral and brightly coloured fish. Interestingly, for ten years the experience of his tour of the South Seas did not seem to influence his work, except perhaps for a handful of sculptures he made on his return. Referring to the colours of the Tahitian skies, Matisse recalled in 1931 that they 'cannot bear fruit except in memory, after they have been weighed against our own colours. I expect that some of it will filter into my painting, later on.'[34]

In September 1930, Matisse was invited to become a member of the jury for the Carnegie International Exhibition Prize held in Pittsburgh, Pennsylvania,[35] on which occasion the winner was Picasso. During the trip, collector Albert C. Barnes commissioned Matisse to create a mural decoration for the central gallery of his foundation, in Merion, Philadelphia. This proved to be a very challenging undertaking, as the mural had to be set in three separate lunettes above large French windows. Matisse returned to Nice, renting a warehouse to begin his work with small studies in pencil and oil, and again used painted cut-out paper and photographs. Unfortunately, when completed in 1932, Matisse's first attempt at the commission failed, as he was supplied with inaccurate measurements. Instead of trying to re-adjust the existing work, he decided to start all over again on a second version, which was successfully completed in 1933. *The Dance* (fig.13) was somewhat confined in its composition and use of colour, marking a return to the decorative style of his earlier career.

Now in his sixties and exhausted by his efforts on the Barnes commission, Matisse did not produce much new work until 1935. Meanwhile, two of Matisse's paintings entered the collection of

The Museum of Modern Art in New York and four retrospectives were held between 1930 and 1931, enhancing his international reputation.[36] A source of great pleasure for Matisse was the commission from publisher Skira to illustrate a new edition of the poems of Stéphane Mallarmé in the summer of 1931, to be published in 1932. This was the first of several works of book illustration Matisse would make.[37]

From 1935 to 1938, Matisse slowly increased his production of easel paintings, using the female nude as his principal subject, often in decorative costumes and in a variety of incrementally different poses and settings. His *Woman in Blue* (fig.48) appears almost as a patchwork of colour and suggests his continued interest in the cut-out technique. His well-known group of drawings, *Themes and Variations,* displays the extent of his research in the period, with a succession of different versions of the same image of a single model, in what Matisse described as 'a motion picture film of the feeling of an artist' (fig.14).[38] The model for *Woman in Blue* was Lydia Delectorskaya, who had helped Matisse on the production of The Barnes Foundation mural and had originally been employed to care for Mme Matisse, who was in poor health. Delectorskaya occasionally modelled for Matisse, and remained his assistant until his death.

Throughout the 1930s, Matisse worked on different types of commissions, of which his most important remain his

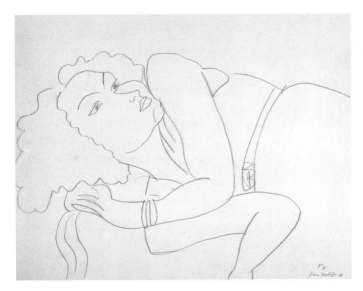

14. Henri Matisse
Themes and Variations, F7
1941
Black crayon on paper
40 × 52
Musée de Grenoble

designs for the sets and costumes for *Le Rouge et le Noir* (also known as *L'Étrange Farandole*), a ballet with music from Dmitri Shostakovich's First Symphony and choreography again by Massine.[39] Re-employing the cut-out technique, this commission would become an important precursor to Matisse's later work with the medium.

At the beginning of the Second World War, Matisse returned to Cimiez, a small suburb of Nice, to the Hôtel Régina to which he had moved in 1938. His relationship with his wife had been declining for some time, and in 1940 their separation became official. Matisse had been in frequent ill health and in March 1941 was operated on for duodenal cancer. Soon after, he became incapable of remaining on his feet for any significant length of time, and indeed would remain semi-invalid for the rest of his life. Despite this, it is known that Matisse did not stop painting during this period, often doing so from his bed or wheelchair, and he worked on another illustrated book, *Florilège des Amours de Ronsard*, published by his friend Albert Skira.

The cut-outs

> Instead of drawing an outline and filling in the color ... I am drawing directly in color.[40]

In June 1943, to avoid the risk of bombardment in Nice, Matisse moved to the Villa le Rêve in Vence, where he remained until 1949. Throughout this period he received visits from a number of artists, including Picasso, but despite continued recognition he started to isolate himself more and more, becoming increasingly absorbed with cut-outs. He had previously used the technique at the earlier stages of production for *Large Reclining Nude* (fig.47) and *Still life with Shell*, for *L'Étrange Farandole* and for the covers of *Cahiers d'Art* in 1937 and *Verve*[41] (fig.49), but during the 1940s it became for Matisse an art form in its own right, and his sole method of resolving his 'eternal conflict between drawing and color'.[42] Tériade, the publisher, persuaded Matisse to produce *Jazz*, a book entirely devoted to his cut-outs, which was published in 1947 (fig.50).

Although Matisse had worked throughout his life with remarkable fervency and enthusiasm, he was greatly affected when he heard, in 1944, that his daughter Marguerite and wife Amélie, both active in the Résistance, had been arrested by the Gestapo. Matisse was

relieved when both women were eventually freed at the end of the war, and visited Paris in 1945, where he was honoured by a retrospective at the Salon d'Automne, followed later that year by an exhibition at the Victoria and Albert Museum in London.

Despite ill health confining him to bed for long periods, Matisse continued to work on cut-out compositions and at the same time took up his brush to begin painting once again. Between 1946 and 1948 he produced his well-known Vence Interiors, blurring the lines between inside and out with swathes of rich, unbounded colouring (see frontispiece). Nevertheless, ending ten years of collaboration with dealer Paul Rosenberg, Matisse decided gradually to distance himself from painting to focus on decorative projects. At the end of 1946 he created much larger cut-outs as part of the production of silkscreened prints and tapestries, strongly influenced by his travels in Tahiti (figs.51, 52), and began to fill the walls of his studio at the Villa le Rêve with cut-outs of greater complexity. His repeated use of the seaweed and leaf motifs reveals his continuing search to give his cut-outs a life of their own (figs.55, 56).

In late 1947, still unwell and by now in his seventies, Matisse received a visit from a Dominican novice, Brother Rayssiguier,[43] who offered him an arduous commission to decorate the as-yet-unbuilt Chapel of the Rosary at Vence (fig.15). It took the help of Father Marie-Alain Couturier, a leading advocate of modern religious art, to convince the conservative authorities that Matisse was suitable for the commission. The artist accepted, later recounting that it was an opportunity to express himself '[…] in the totality of form and color […]'.[44] The work saw a progression from gouache technique to pure aesthetic, as Matisse employed black drawing on white ceramics to amplify light entering through stained-glass surfaces of colour. Matisse used a scale model of the chapel and overlaid cut-outs for the stained-glass windows, ceramics and clerical vestments (fig.54).[45]

In 1949, Matisse returned to the Hôtel Régina and continued working on his decorations for the Vence chapel. Meanwhile, exhibitions in his son Pierre's gallery in New York and later at the Musée d'art moderne in Paris were the first shows to include a large number of Matisse's cut-outs, further establishing them as an art form, albeit attracting adverse criticism.

From 1950 to 1954, Matisse created his most ambitious work

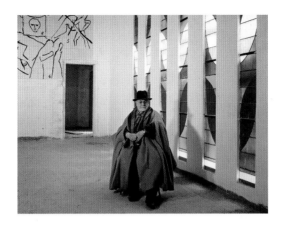

15. Henri Matisse in the Vence Chapel, 1 January 1951

with the cut-out technique, using interplay between figuration, the decorative and sometimes the abstract. Meanwhile, he affirmed his position as a leading international artist, winning first prize at the 25th Venice Biennale in 1950. In 1951, The Museum of Modern Art in New York held a retrospective of Matisse's work, with the director, Alfred H. Barr, Jr., publishing his famous monograph *Matisse: His Art and His Public* the same year. In 1952, due to ill health, Matisse was unable to attend the inauguration of the Musée Matisse in Le Cateau-Cambrésis and instead was represented by Marguerite and Jean. Nevertheless, that year he still managed to produce his legendary *Blue Nudes* which reprised his long-held interest in exploring the female form in a variety of poses, almost as if sculpting the nudes into the paper (fig.57).

In 1953, the Tate Gallery, London held an exhibition of Matisse's work. That same year he produced the highly abstract works *Memory of Oceania* and *The Snail* (figs.58, 59). His final, though incomplete, commission was a stained-glass window for Nelson Rockefeller in 1954, in memory of Rockefeller's mother, Abby Aldrich, one of the founders of The Museum of Modern Art. Matisse worked on the window until the very end, with the relentless passion and drive that characterised his entire life's work. He died on 3 November 1954, in Cimiez, at the age of 84.

I am unable to distinguish between the feeling I have for life and my way of expressing it.[46]

16
The Dinner Table
1896–7
Oil paint on canvas
100 × 131
Private collection

17
Still Life Against the Light
1899
Oil paint on cardboard
74 × 93.5
Private collection

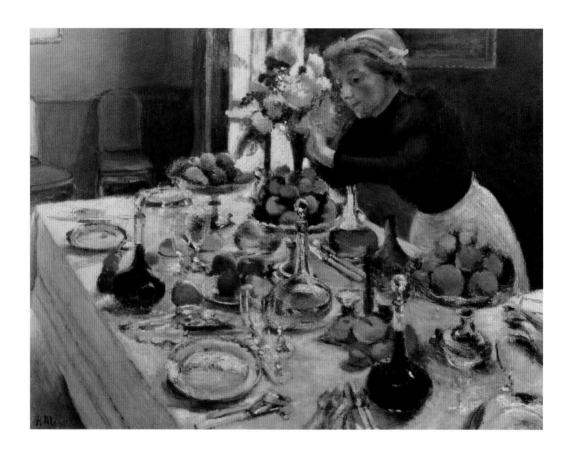

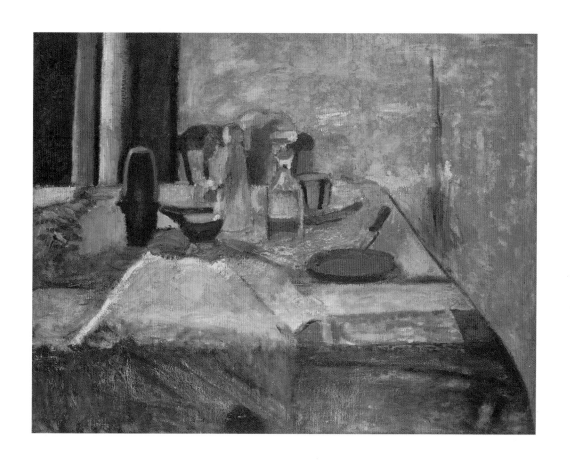

18
The Serf
c.1900–4
Bronze
92.3 × 34.5 × 33
The Museum of Modern
Art, New York

19
Male Model
c.1900
Oil paint on canvas
99.3 × 72.7
The Museum of Modern
Art, New York

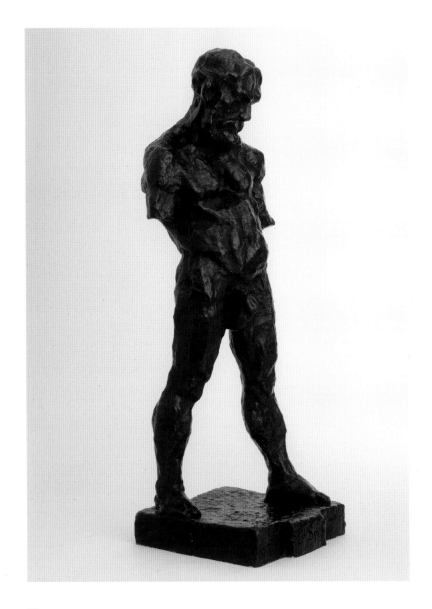

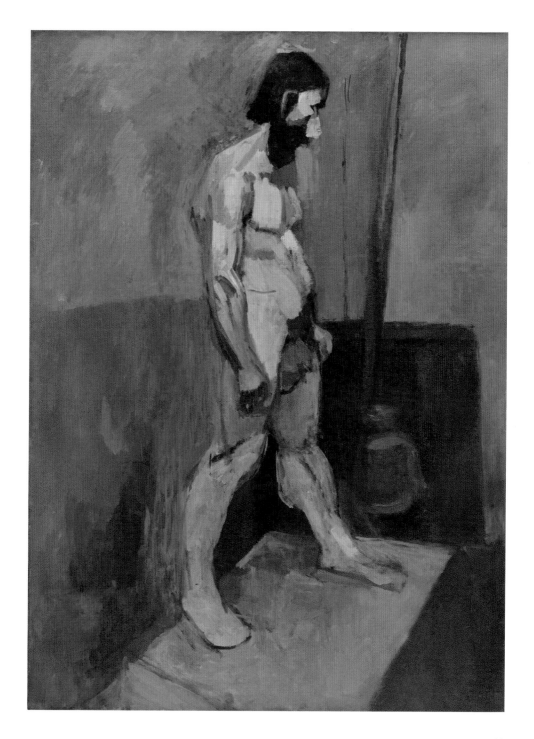

20
Carmelina
1903
Oil paint on canvas
81.3 × 59
Museum of Fine Arts,
Boston

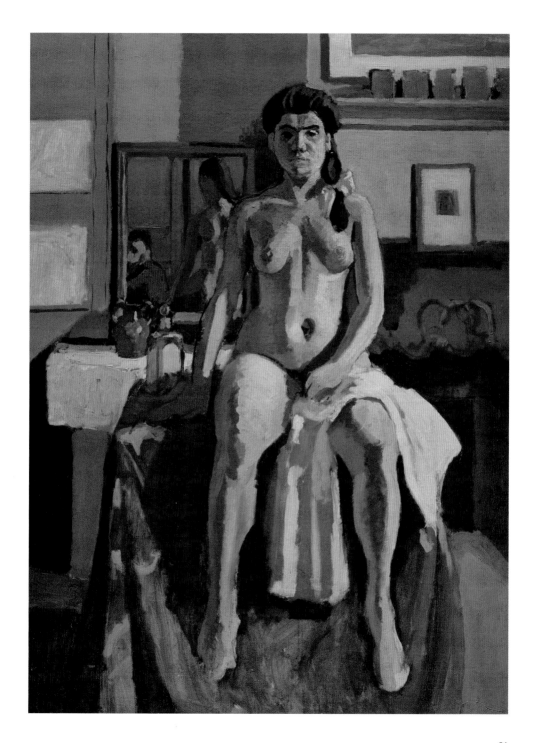

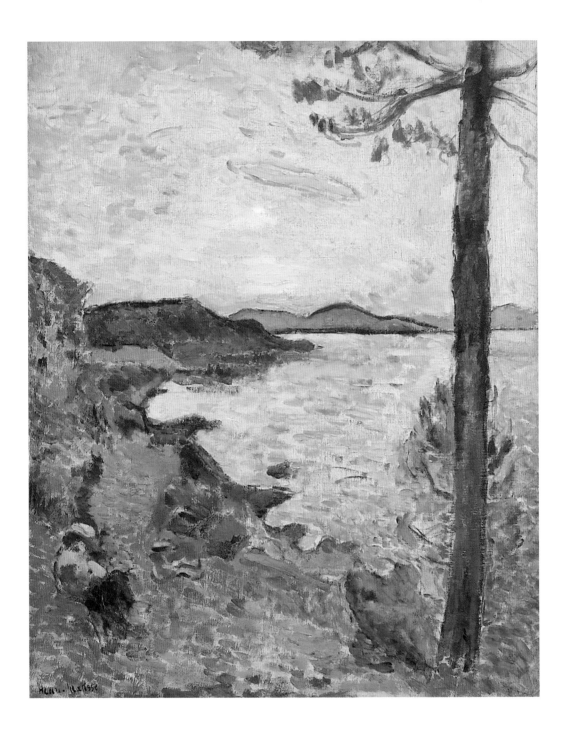

21
The Gulf of Saint-Tropez
1904
Oil paint on canvas
65.1 × 50.5
Kunstsammlung
Nordrhein-Westfalen,
Düsseldorf

22
Luxe, calme et volupté
1904
Oil paint on canvas
98.5 × 118.5
Musée d'Orsay, Paris

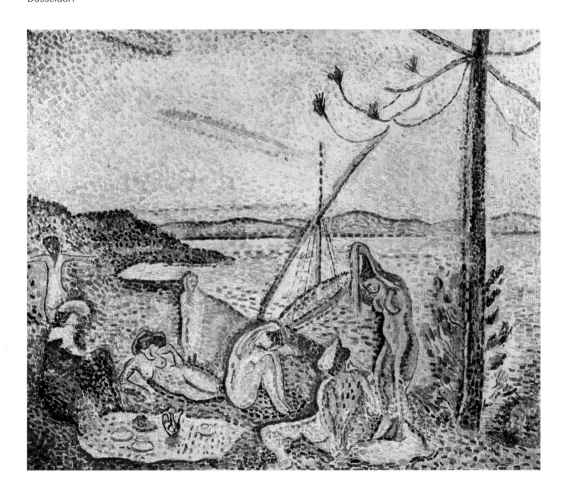

23
Open Window, Collioure
1905
Oil paint on canvas
55.3 × 46
National Gallery of Art,
Washington

24
Woman with a Hat
1905
Oil paint on canvas
80.7 × 59.7
San Francisco Museum
of Modern Art

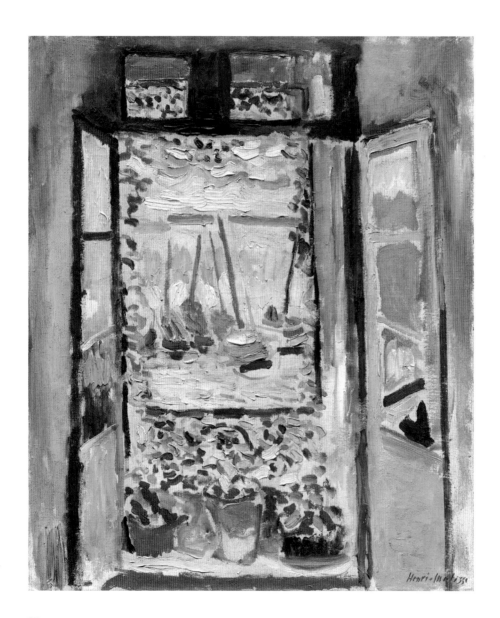

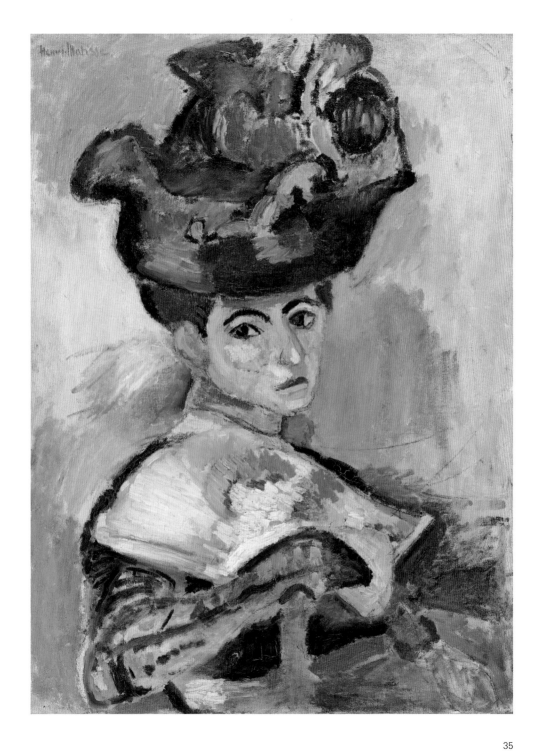

25
Le Bonheur de vivre
1905–6
Oil paint on canvas
175.6 × 241
The Barnes Foundation,
Philadelphia

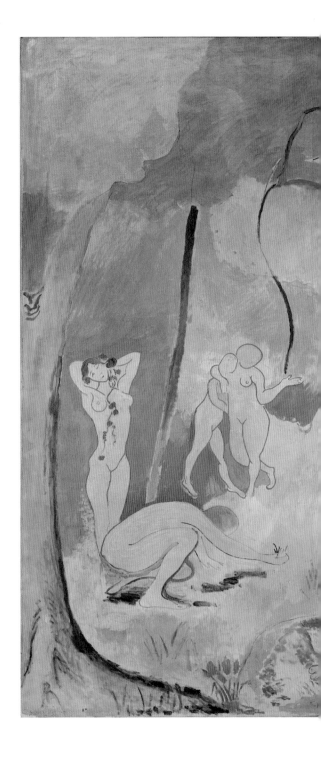

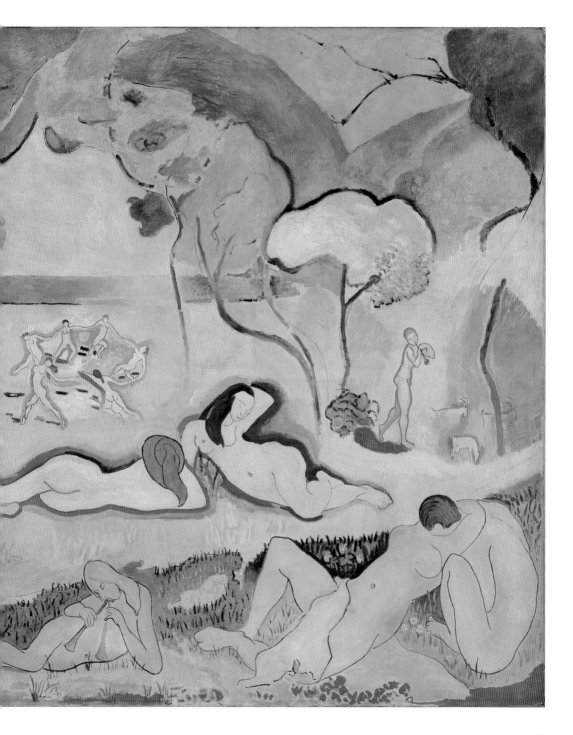

26
Blue Nude:
Memory of Biskra
1907
Oil paint on canvas
92.1 × 140.3
The Baltimore
Museum of Art

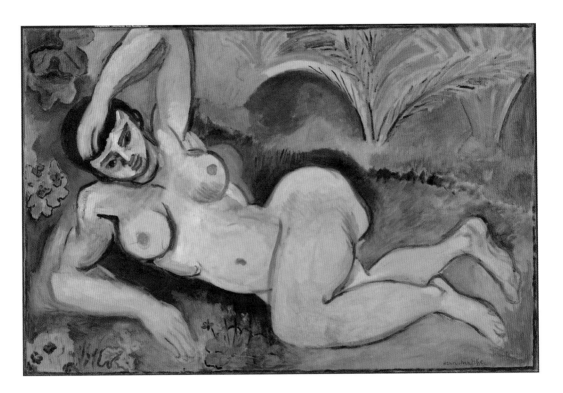

27
Reclining Nude, I
Winter 1906–7
Bronze
34.3 × 50.2 × 28.6
The Museum of Modern
Art, New York

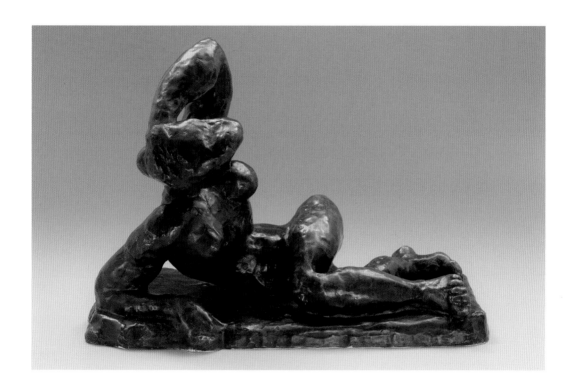

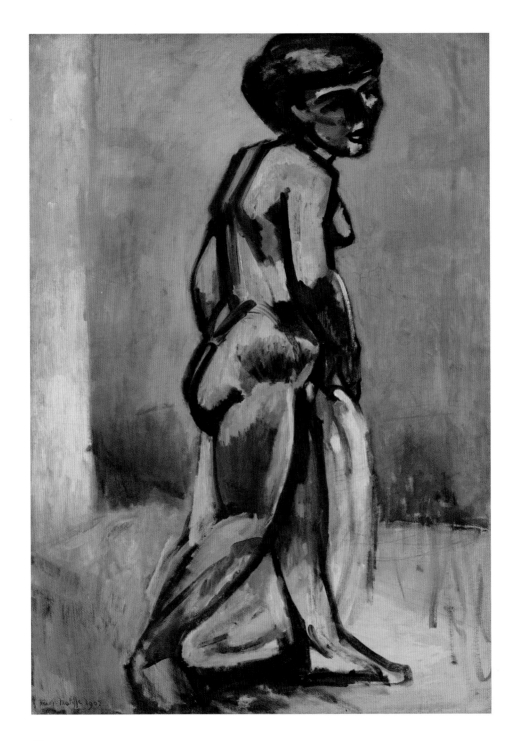

28
Standing Nude
1907
Oil paint on canvas
92.1 × 64.8
Tate

29
Le Luxe II
1907–8
Distemper on canvas
209.5 × 139
Statens Museum for
Kunst, Copenhagen

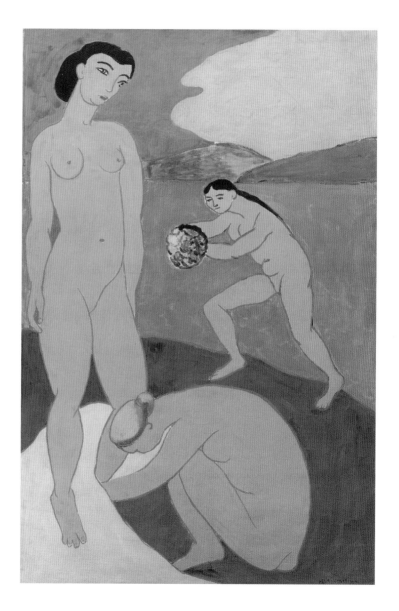

30
Harmony in Red
(The Red Room)
1908
Oil paint on canvas
180.5 × 221
State Hermitage Museum,
St Petersburg

31
Bathers with a Turtle
1907–8
Oil paint on canvas
181.6 × 221
Saint Louis Art Museum

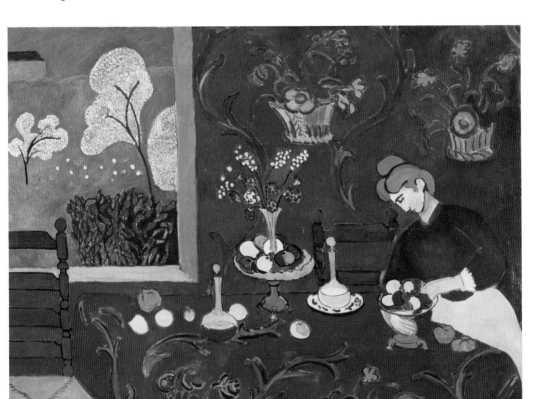

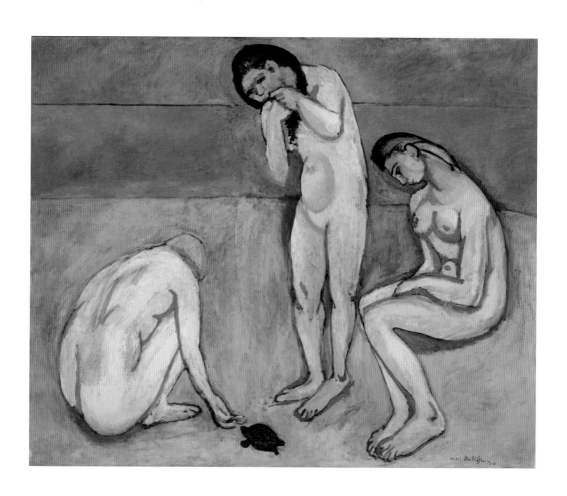

43

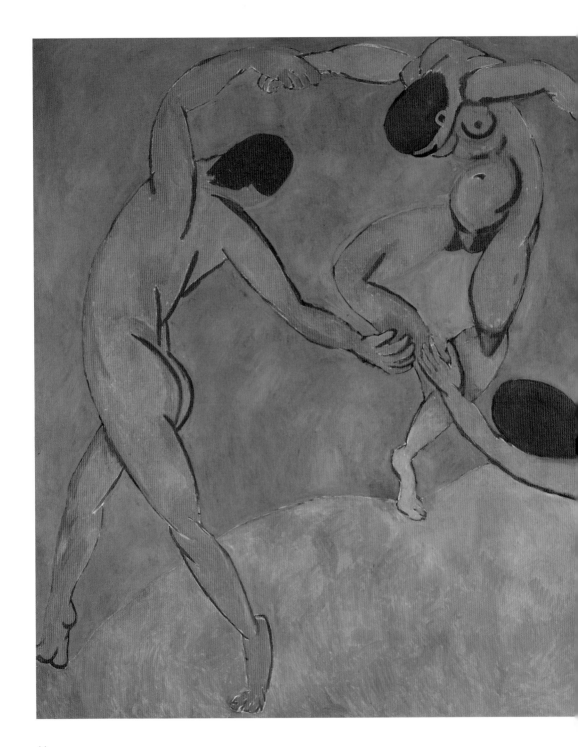

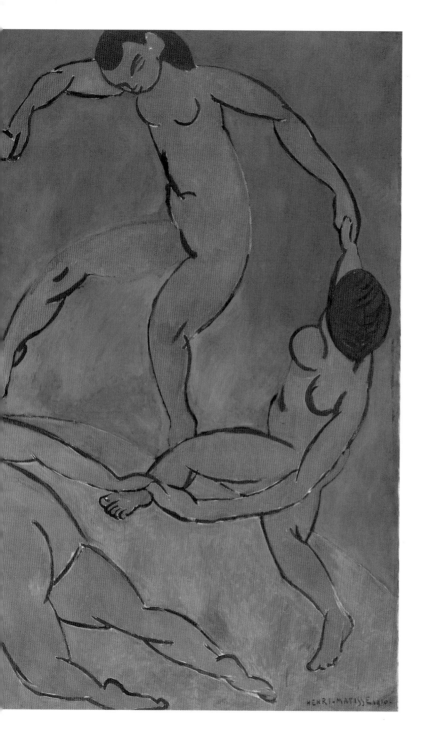

32
Dance II
1910
Oil paint on canvas
260 × 391
State Hermitage Museum,
St Petersburg

33
The Pink Studio
1911
Oil paint on canvas
181 × 221
Pushkin Museum of Fine
Arts, Moscow

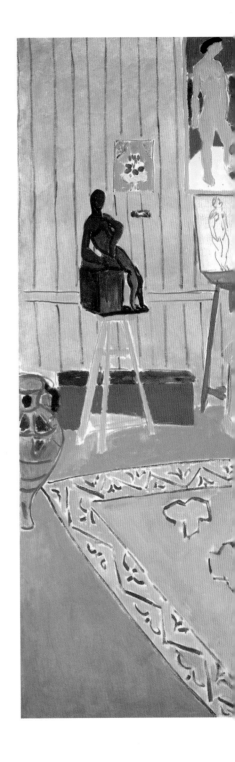

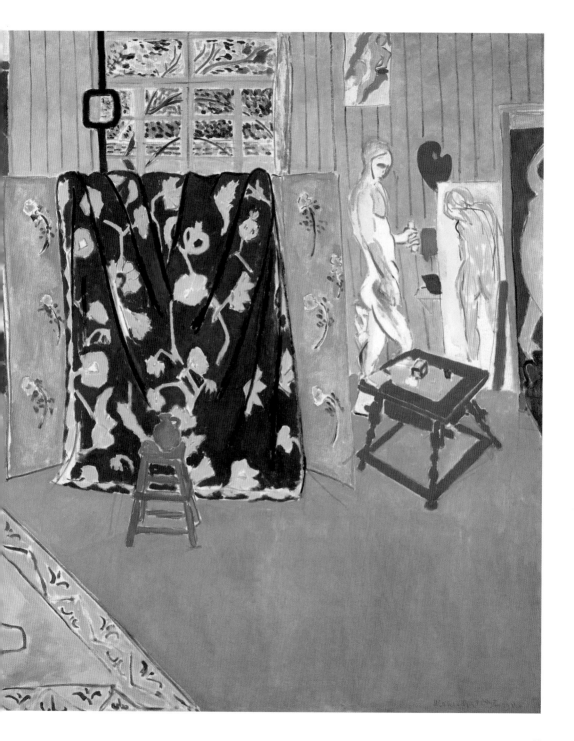

34
The Painter's Family
1911
Oil paint on canvas
143 × 194
State Hermitage Museum,
St Petersburg

35
The Red Studio
Autumn 1911
Oil paint on canvas
181 × 219.1
The Museum of Modern
Art, New York

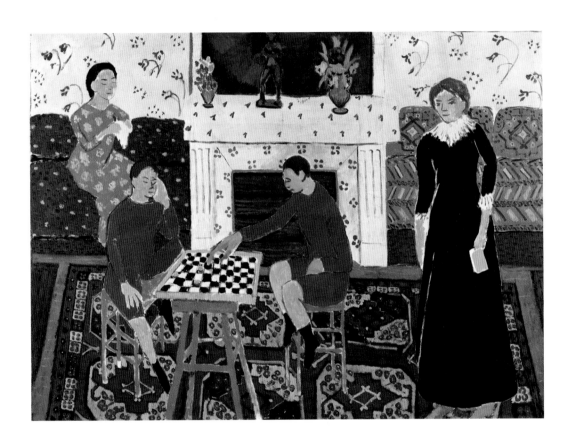

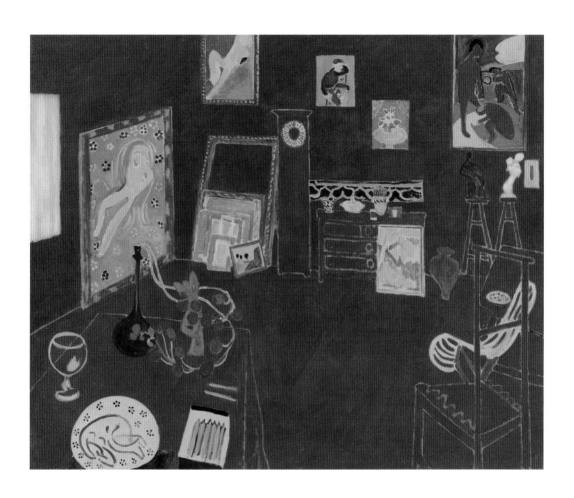

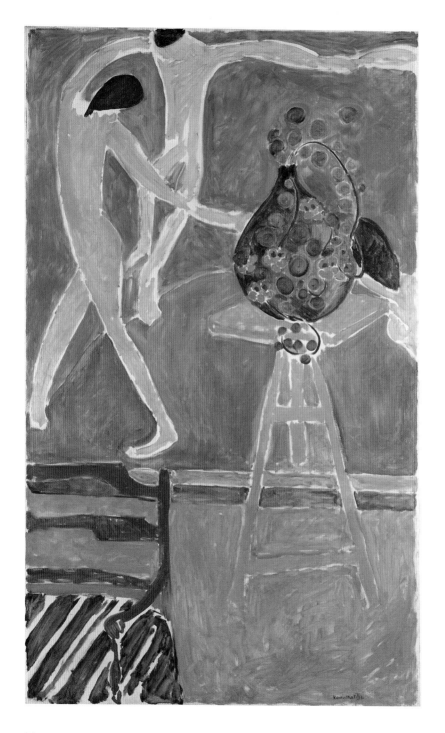

36
Nasturtiums with the
Painting 'Dance' I
1912
Oil paint on canvas
191.8 × 115.3
Metropolitan Museum
of Art, New York

37
The Moroccan Café
1912–13
Oil paint on canvas
176 × 210
State Hermitage Museum,
St Petersburg

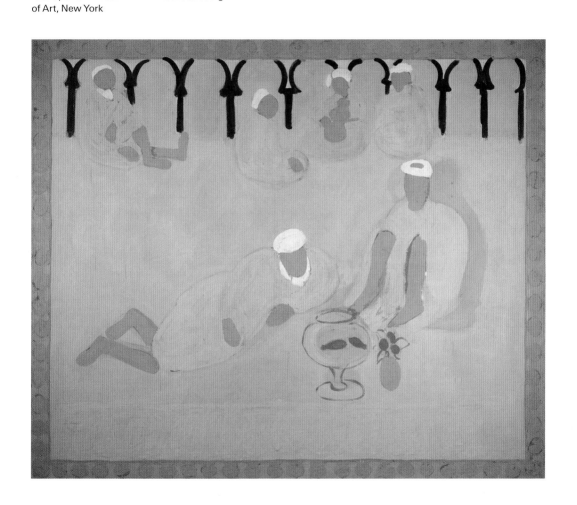

38
*Mademoiselle Yvonne
Landsberg*
1914
Oil paint on canvas
147.3 × 97.5
Philadelphia Museum
of Art

39
*Portrait of Madame
Matisse*
1913
Oil paint on canvas
146 × 97.7
State Hermitage Museum,
St Petersburg

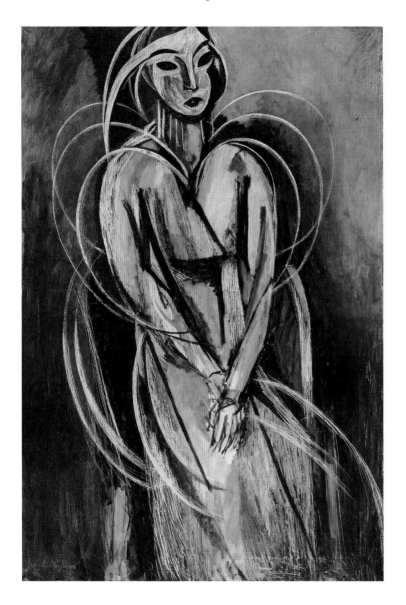

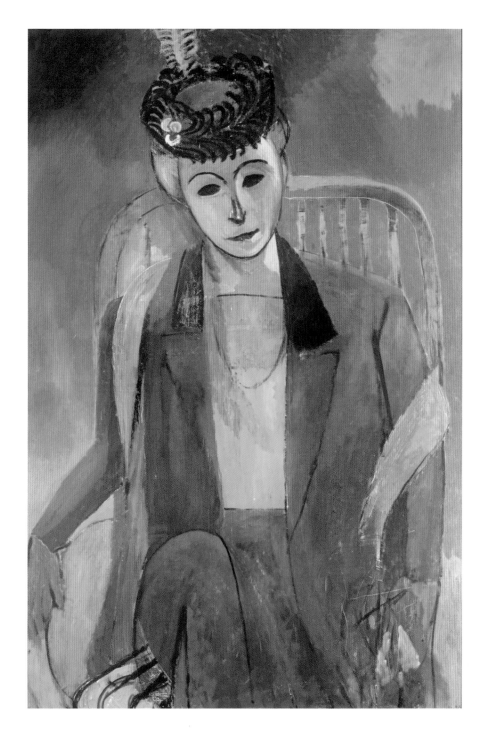

40
*Still Life after Jan Davidsz.
de Heem's 'La Desserte'*
Summer – autumn 1915
Oil paint on canvas
180.9 × 220.8
The Museum of Modern
Art, New York

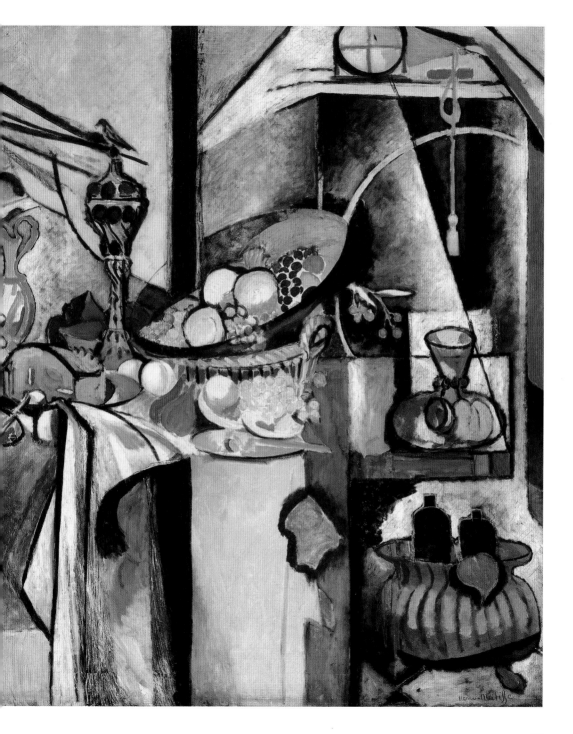

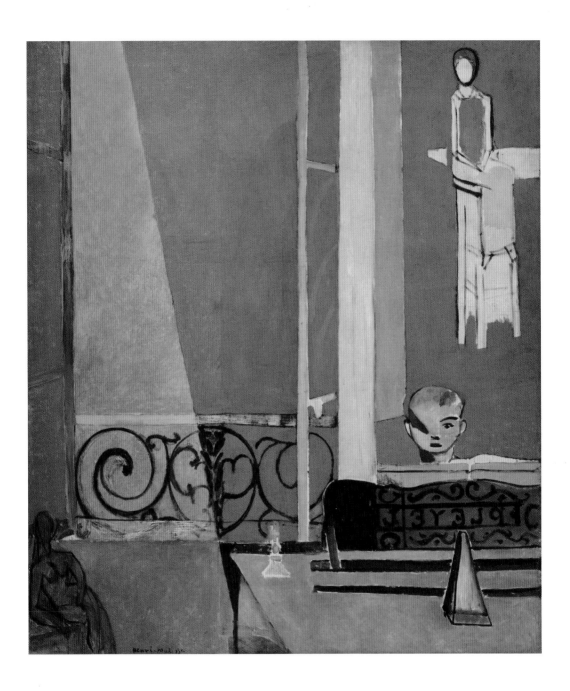

41
The Piano Lesson
Late summer 1916
Oil paint on canvas
245.1 × 212.7
The Museum of Modern
Art, New York

42
Bathers by a River
March 1909–10, May –
November 1913 and early
spring 1916 – October (?)
1917

Oil paint on canvas
260 × 392
The Art Institute, Chicago

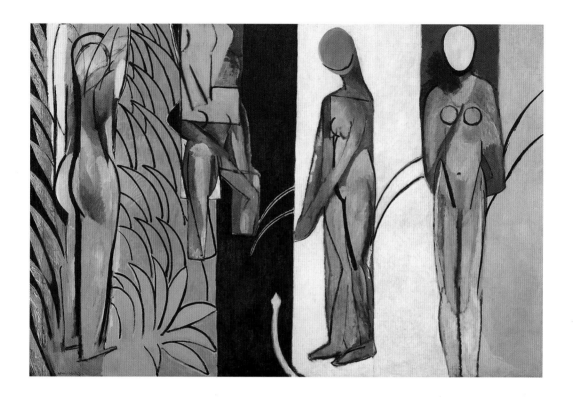

43
Interior at Nice
1919 or 1920
Oil paint on canvas
132.1 × 88.9
The Art Institute, Chicago

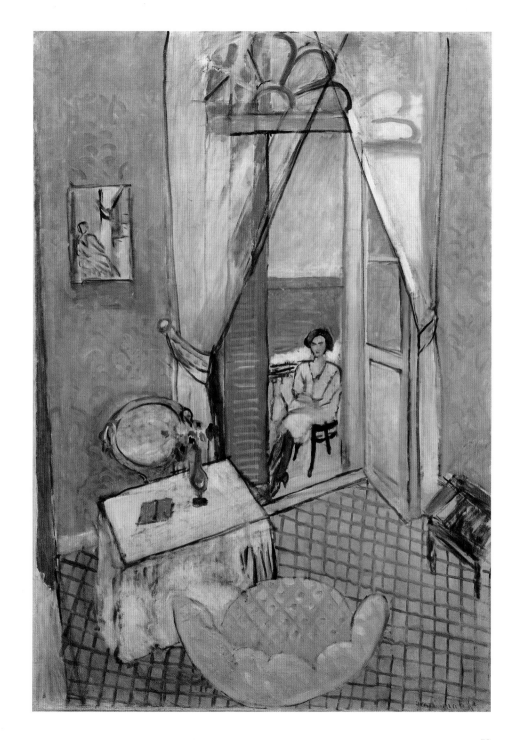

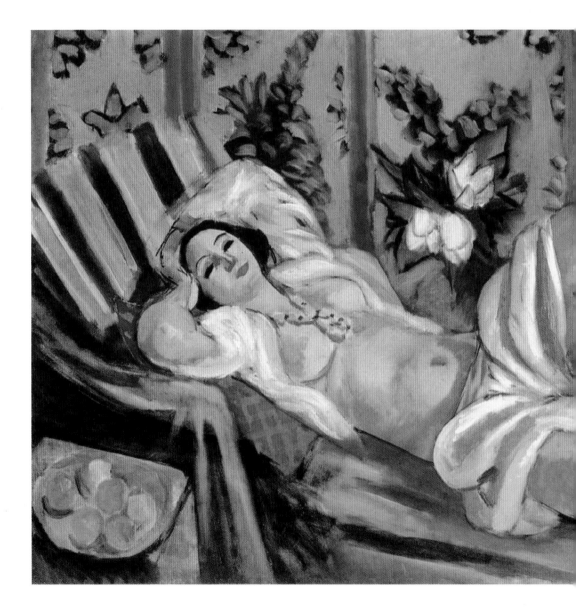

44
Odalisque with Magnolias
1923–4
Oil paint on canvas
65 × 81
Private collection

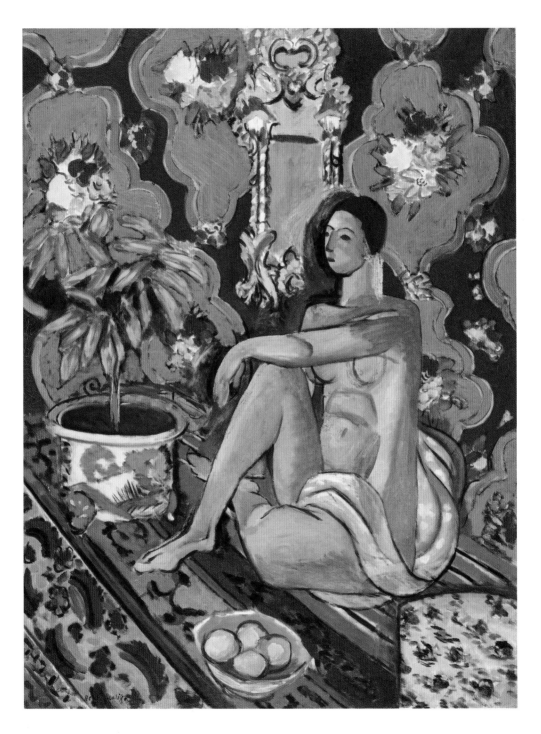

45
*Decorative Figure on an
Ornamental Ground*
Late 1925 – spring 1926
Oil paint on canvas
129.9 × 98.1
Musée national d'art
moderne, Centre
Pompidou, Paris

46
Large Seated Nude
1925–9
Bronze
79.4 × 77.5 × 34.9
The Museum of Modern
Art, New York

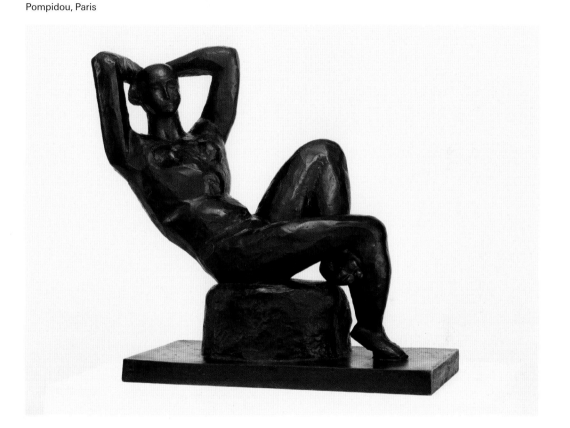

47
Large Reclining Nude
(*The Pink Nude*)
1935
Oil paint on canvas
66.4 × 93.3
The Baltimore
Museum of Art

48
Woman in Blue
1937
Oil paint on canvas
92.7 × 73.7
Philadelphia Museum
of Art

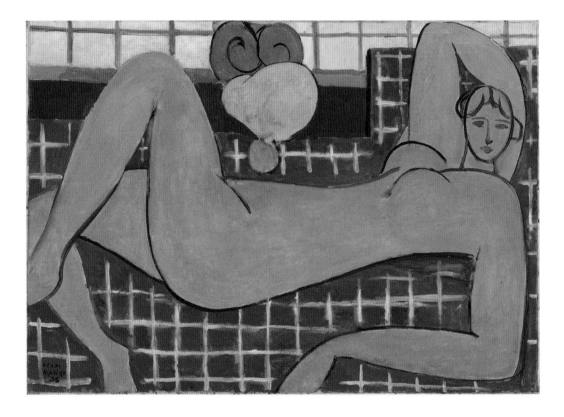

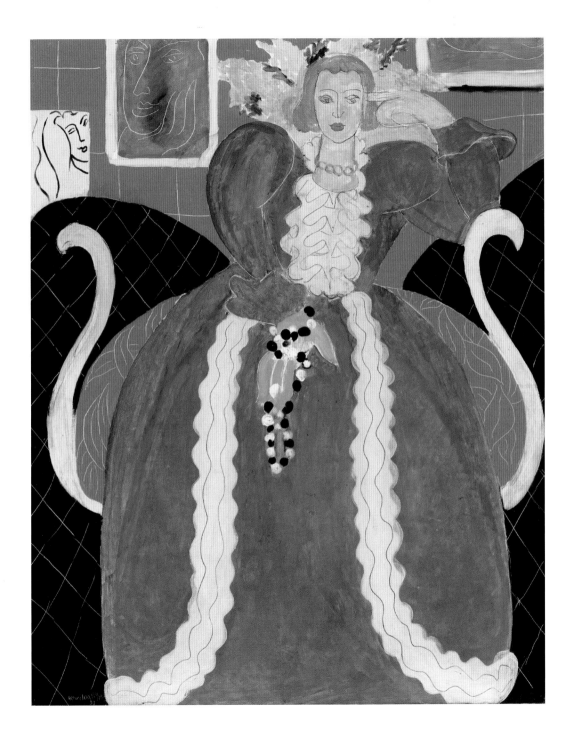

49
Symphonie chromatique.
Cover maquette for
'Verve II'
1939
Coloured papers, cut
and pasted

35.2 × 55.3
Hilti Art Foundation,
Schaan

50
Icarus. Maquette for
plate VIII – 'Jazz'
1944
Gouache on paper, cut
and pasted, mounted
on canvas

43.4 × 34.1
Musée national d'art
moderne, Centre
Pompidou, Paris

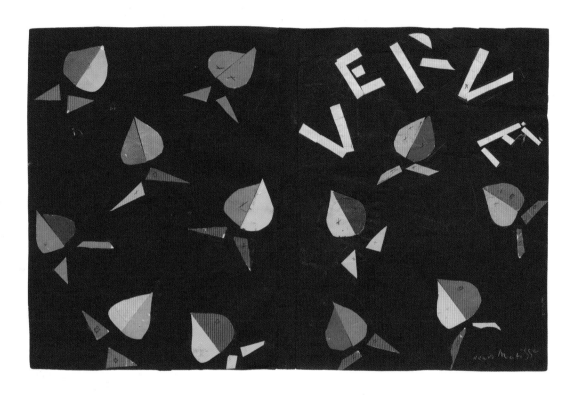

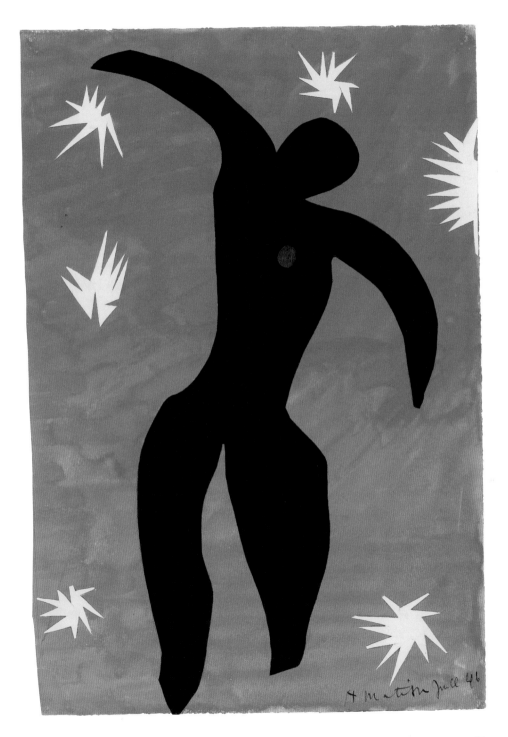

51
Oceania, the Sea
Summer 1946
Gouache on paper, cut
and pasted, on paper,
mounted on canvas

178.5 × 392.8
Musée départemental
Matisse, Le Cateau-
Cambrésis

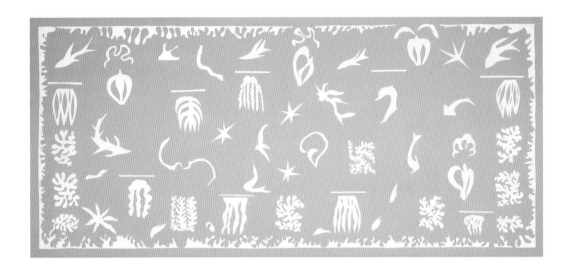

52
Oceania, the Sky
Summer 1946
Gouache on paper, cut and
pasted, on paper, mounted
on canvas

178.3 × 369.7
Musée départemental
Matisse, Le Cateau-
Cambrésis

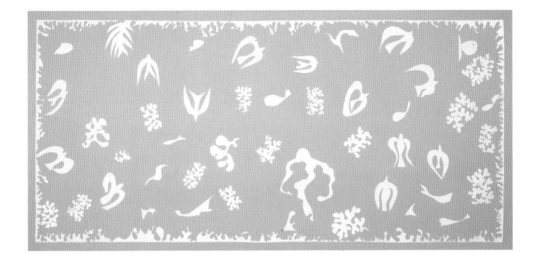

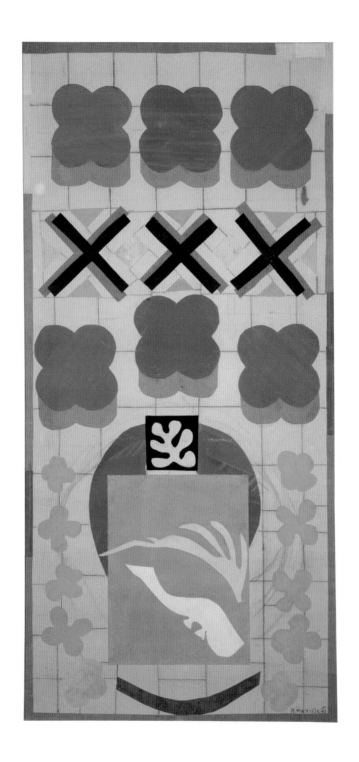

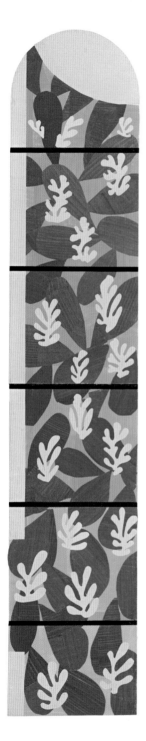
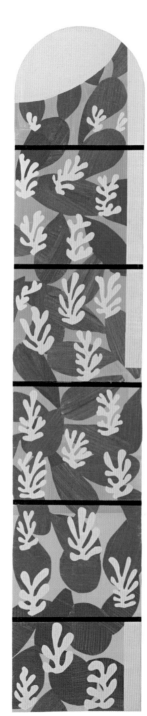

53
Chinese Fish. Maquette for stained-glass window
1951
Gouache on paper, cut and pasted, and charcoal on white paper, mounted on canvas
189.9 × 90.2
Collection Patricia Phelps de Cisneros

54
The Tree of Life.
Final maquette for stained-glass window in the apse of the Chapel of the Rosary of the Dominican Nuns of Vence
1949
Gouache on paper, cut and pasted
515 × 252
The Vatican Museums. Collection of Modern Religious Art

55
The Eskimo
1947
Gouache on paper, cut
and pasted
40.5 × 86
Designmuseum Danmark,
Copenhagen

56
The Panel with Mask
1947
Gouache on paper, cut
and pasted
110 × 53
Designmuseum Danmark,
Copenhagen

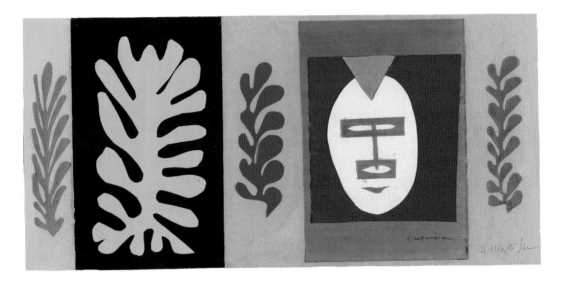

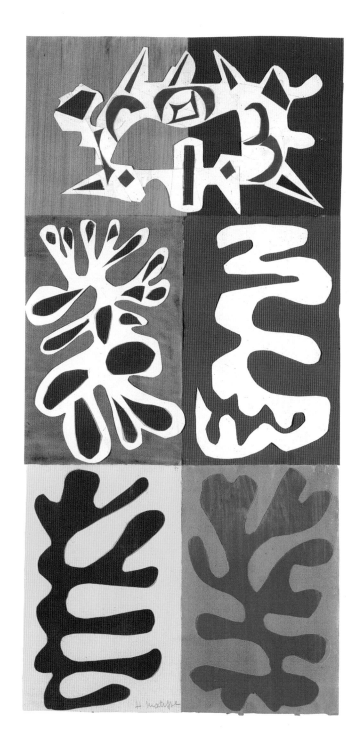

57
Blue Nude III
Spring 1952
Gouache on paper, cut and
pasted, on white paper,
mounted on canvas
112 × 73.5
Musée national d'art
moderne, Centre
Pompidou, Paris

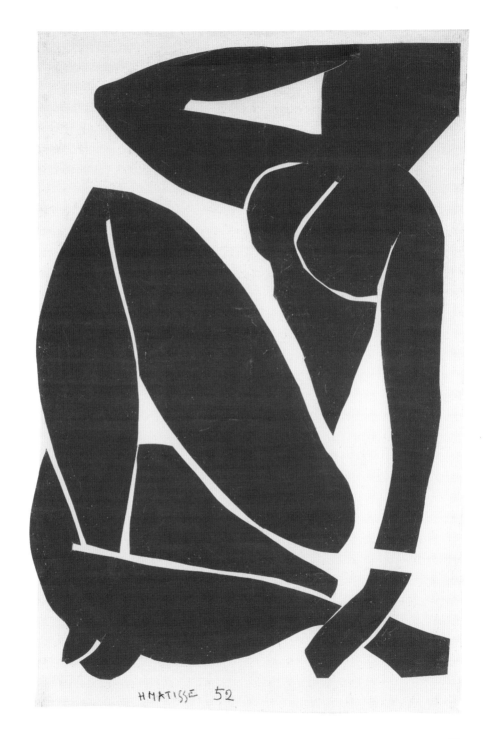

HMATISSE 52

58
Memory of Oceania
Summer 1952 – early 1953
Gouache on paper, cut and
pasted, and charcoal on
paper, mounted on canvas
284.4 × 286.4
The Museum of Modern
Art, New York

59
The Snail
1953
Gouache on paper, cut and
pasted, on paper, mounted
on canvas
286.4 × 287
Tate

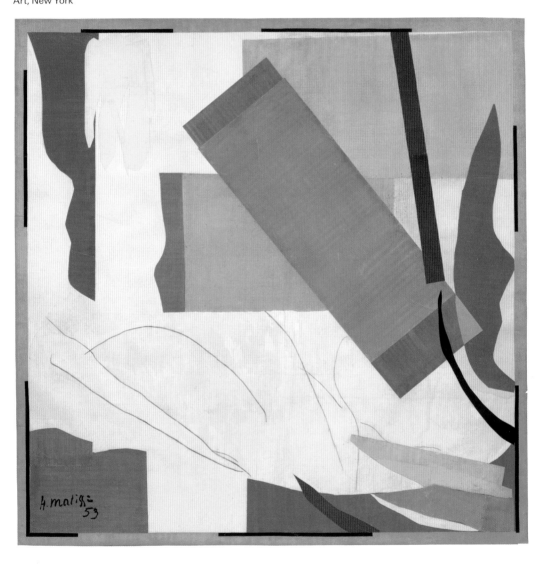

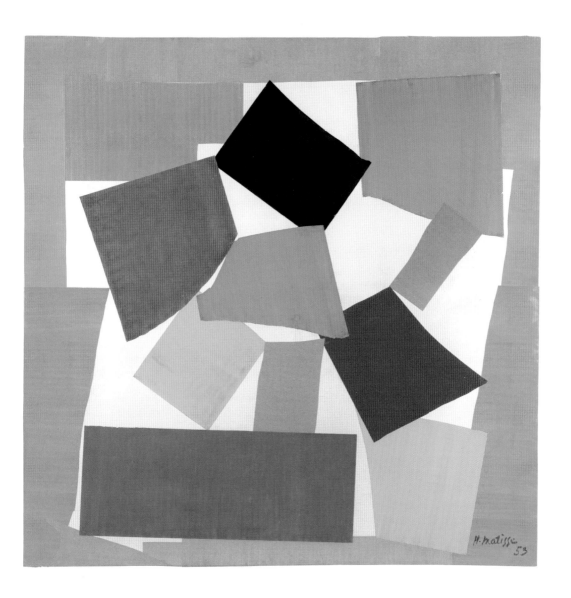

Notes

Index

1. Excerpt from Matisse's 'Notes of a Painter', 1908 in Alfred H. Barr, Jr., *Matisse: His Art and His Public*, The Museum of Modern Art, New York 1951, p.119.

2. Hilary Spurling, *Matisse: The Life*, London 2009, p.18.

3. Ibid., p.10.

4. Ibid., p.21.

5. Barr 1951, p.14.

6. Xavier Girard, *Matisse, The Sensuality of Colour*, London 1994, p.16.

7. Ibid., p.17.

8. Girard 1994, p.23.

9. The work was exhibited at the Salon de la Société Nationale in April 1897 and provoked ferocious criticism.

10. Girard 1994, p.29.

11. Barr 1951, p.40.

12. Spurling 2009, p.92.

13. Barr 1951, p.58.

14. Girard 1994, pp.45–6.

15. 'Donatello among the wild beasts!', in John Elderfield, *Henri Matisse: A Retrospective*, The Museum of Modern Art, New York 1992, p.134.

16. Barr 1951, p.55.

17. 'The buyers were two Americans, a brother and a sister, Leo and Gertrude Stein […] In fact it was Sarah Stein, the wife of Leo and Gertrude's elder brother Michael, who fell for the painting and managed after much argument to overcome the others' doubts.' Spurling 2009, pp.132–3.

18. Elderfield 1992, p.133.

19. 'Estienne: Interview with Matisse, 1909', in Jack D. Flam, *Matisse on Art*, London 1973, p.49.

20. The Académie Matisse remained open until 1911.

21. Spurling 2009, p.169.

22. The painting, which had initially been painted in blue, used 'the richly decorative tradition into which Matisse was born'. Spurling 2009, p.172.

23. Matisse borrowed the circle of dancers in the background of *Le Bonheur de vivre* (*Joy of Life*) as the subject for *Dance*. Matisse would often reuse subjects across different works.

24. Girard 1994, p.61.

25. Elderfield 1992, p.182.

26. Girard 1994, p.79.

27. Spurling 2009, pp.259–60

28. Elderfield 1992, p.237.

29. Barr 1951, p.182.

30. Spurling 2009, p.316.

31. Ibid., p.324

32. From November 1918 to the summer of 1921 he rented different rooms at Hôtel de la Méditerranée in Nice.

33. Barr 1951, p.219.

34. Girard 1994, p.109.

35. Matisse himself won the prize in 1927.

36. February – March 1930 at the Thannhauser gallery in Berlin; June – July 1931 at Georges Petit gallery in Paris; August – September 1931 at the Kunsthalle Basel; November –

December 1931 at The Museum of Modern Art, New York.

37. James Joyce's *Ulysses*, to be published by the Limited Editions Club in New York in 1935; Florilège des Amours de Ronsard, 1941; Henri de Montherlant's *Pasiphae*, 1941; Charles Baudelaire's *Les Fleurs du Mal*, 1944; Marianna Alcaforado's *Les Lettres d'une religieuse portugaise*, 1946.

38. Elderfield 1992, p.359.

39. First performed in 1939 in Monte Carlo, then Paris and later New York.

40. Elderfield 1992, p.413.

41. *Cahiers d'Art* issues 3-5 were dedicated entirely to Matisse's recent drawings. Matisse also designed covers for the first and eighth issues of *Verve* in 1937 and 1939, as well as an issue dedicated entirely to his own recent work, 'Henri Matisse. De la couleur' ('Henri Matisse: Colour'), published in 1945.

42. Elderfield 1992, p.413.

43. Monique Bourgeois, who had been Matisse's nurse and later his model, became Sister Jacques of the Dominican nuns at Vence, and introduced Brother Rayssiguier to the artist.

44. Anne Coron, 'Gouache Cut-Outs: Technique to Aesthetics', in Matisse, *La couleur découpée*, Musée Matisse, Le Cateau-Cambrésis, Somogy Éditions d'art, Paris 2013, p.26.

45. The chapel was completed in 1951.

46. Barr 1951, p.119.

First published 2014 by order of the Tate Trustees
by Tate Publishing, a division of Tate Enterprises
Ltd, Millbank, London SW1P 4RG
www.tate.org.uk/publishing

ISBN 978 1 84976 298 4

Distributed in the United States and Canada by
ABRAMS, New York

Library of Congress Control Number applied for

Designed by Anne Odling-Smee, O-SB Design
Colour reproduction by DL Imaging Ltd, London
Printed in and bound in Italy by Elcograf

Cover: Henri Matisse, *The Snail* 1953 (fig.59)
Frontispiece: Henri Matisse, *Red Interior: Still Life
on a Blue Table* 1947, Oil paint on canvas,
116 × 89, Kunstsammlung Nordrhein-Westfalen,
Düsseldorf

Measurements of artworks are given in
centimetres, height before width.

Photo and copyright credits

Archives H. Matisse figs.1, 2, 17,
30, 49, 54
© The Art Institute, Chicago
figs.42, 43
© 2014 The Barnes
Foundation figs.13, 25
The Bridgeman Art
Library frontispiece, fig.16
© 2014 DeAgostini Picture Library/
Scala, Florence fig.9
André Derain: © ADAGP, Paris and
DACS, London 2014
© Centre Pompidou, MNAM-CCI,
Dist. RMN-Grand Palais/Philippe
Migeat figs.11, 12, 45, 50, 57
François Fernandez fig.4
Mitro Hood fig.26
Dmitri Kessel/Time & Life Pictures/
Getty Images fig.15
Pernille Klemp figs.55, 56
© Musée de Grenoble fig.14
© 2014 Metropolitan Museum of
Art/Art Resource/Scala, Florence
fig.36
© 2014 Museum of Fine Arts,
Boston fig.20
© 2014 The Museum of Modern Art,
New York/Scala, Florence figs.18,
19, 27, 35, 40, 41, 46, 58
Mark Morosse fig.53
© RMN-Grand Palais/Agence Bulloz
fig.7
© 2014 Photo Scala, Florence figs.10,
22, 32, 33, 34, 37, 39
© SMK Photo fig.29
© 2014 Tate Photography figs.8,
28, 59
J.-F. Tomasian figs.51, 52
Ville de Nice – Service
photographique fig.3
© 2014 White Images/Scala,
Florence fig.21

Full collection credits

The Art Institute, Chicago. Charles
H. and Mary F. S. Worcester
Collection fig.42
The Art Institute, Chicago. Gift of Mrs
Gilbert W. Chapman fig.43
The Baltimore Museum of Art. The
Cone Collection, formed by Dr
Claribel Cone and Miss Etta Cone
of Baltimore, Maryland figs.26, 47
Metropolitan Museum of Art, New
York. Bequest of Scofield Thayer,
1982 fig.36
Musée départemental Matisse, Le
Cateau-Cambrésis. Donation de la
Famille Matisse en 2004 figs.51, 52

Musée Matisse, Nice. Bequest of
Mrs Henri Matisse 1960 figs.3, 4
Musée national d'art moderne,
Centre Pompidou. Legacy of
Baroness Eva Gourgaud 1965
fig.11
Musée national d'art moderne,
Centre Pompidou. Purchased
1938 fig.45
Musée national d'art moderne,
Centre Pompidou. Purchased
1975 fig.12
Musée national d'art moderne,
Centre Pompidou. Purchased
1982 fig.57
Museum of Fine Arts, Boston.
Tompkins Collection — Arthur
Gordon Tompkins Fund fig.20
The Museum of Modern Art, New
York. Acquired through the Lillie P.
Bliss Bequest fig.27
The Museum of Modern Art, New
York. Gift and bequest of Florene
M. Schoenborn and Samuel A.
Marx fig.40
The Museum of Modern Art, New
York. Gift of Mr and Mrs Walter
Hochschild (by exchange) fig.46
The Museum of Modern Art, New
York. Kay Sage Tanguy and Abby
Aldrich Rockefeller fig.19
The Museum of Modern Art, New
York. Mr and Mrs Sam Salz Fund
fig.18
The Museum of Modern Art, New
York. Mrs Simon Guggenheim
Fund figs.41, 35, 58
National Gallery of Art, Washington
DC. Collection of Mr and Mrs John
Hay Whitney fig.23
Le Petit Palais, Paris. Gift of M. and
Mme Henri Matisse, 1936 fig.7
Philadelphia Museum of Art. Gift of
Mrs John Wintersteen 1956 fig.48
Philadelphia Museum of Art. The
Louise and Walter Arensberg
Collection 1950 fig.38
Saint Louis Art Museum. Gift of Mr
and Mrs Joseph Pulitzer Jr fig.31
San Francisco Museum of Modern
Art. Bequest of Elise S. Haas fig.24
Statens Museum for Kunst,
Copenhagen. J. Rump Collection.
Gift 1928 fig.29
Tate. Purchased 1958 fig.8
Tate. Purchased 1960 fig.28
Tate. Purchased with assistance
from the Friends of the Tate Gallery
1962 fig.59